The Universal Guide to
PRODUCING
MOVIES

By: Jeral Clyde II

Printed in the United States of America
Edited By: My Gorgeous and Smart Wife, Elizabeth Clyde

Note: This book is formatted as a guide. Take notes in the
additional spacing, apply the information, and we look
forward to seeing your project come to life.

Dedication

I dedicate this book to my family and every Producer in the world. The future is brighter, trust me I'm a creator.

Jeral Clyde II

"The doers are the major thinkers. The people that really create the things that change this industry are both the thinker and doer in one person."

Steve Jobs

Table of Contents

The Universal Guide to Producing Movies

You Are A Producer!

"I made my money the old-fashioned way. I was very nice to a wealthy relative right before he died."

Malcolm Forbes

The gratification one experiences when bringing a vision to life on screen is an experience that rarely few individuals obtain the possibility to enjoy. Likewise, redeeming your money as an independent filmmaker is a lot harder when you're not listening to professionals.

This is why you picked up the right book.

In *The Universal Guide to Producing Movies* my hope for you is to learn how to jumpstart your producer début like an industry professional.

There's plenty of motion pictures that are created or perhaps even thought of that are never ever completed. Nonetheless, if you read this book as well as comply with these policies and actions to success, you will produce a great movie.

By following this book, it is extremely unlikely that you will be a part of the majority of people who start, but never finish.

"The length of a film should be directly related to the endurance of the human bladder."

Alfred Hitchcock

The capacity to manage tasks, assemble creative packages, and also handle people is a must as a producer. So is the capability to see the project through from one end to the other.

There are numerous levels to producing:
**Executive Producer, Line Producer,
Co-Producer, Associate Producer, and
Assistant Producer.**

It would be wise at this time to have a pen
handy so when you begin staffing your project
you have the right team in place based on the
definitions provided.

Executive Producers are attributed to the film
by creating the economic and/or creative
package that make the motion picture possible.
They can supply money for insurance policies,
gap money, bridge cash, and also even
start-up cash.

The majority of producers will certainly be
associated with all aspects of the filmmaking
procedure which consist of choosing the film
writers, the casting process, editing procedure
and working with many more roles as you will
learn throughout this book.

Producers also aid in managing cast and crew, navigating the distribution process and advertising.

Essentially, from development to distribution, producers are hands on. They are commonly the first one's on the film and the last one off a film. You must possess that level of dedication or find a team that does.

A **Line Producer** is in charge of remaining within the budget plan. They also oversee the **Production Supervisor** and repair any issues that might develop.

Line Producers are also responsible for capturing and managing productions. Individuals in this position are responsible for ensuring the budget is made and adequately spent and also in charge of explaining areas where the budget has actually run over. If you can afford to hire a line producer it must be someone you trust as they will manage sensitive financial information, and most importantly keep you on budget.



If you do not have the budget or a volunteer you trust for that position, pencil yourself in as the line producer.

Let me tell you why…

The scheduling and budgeting information for your film is the bread and butter of your production. You need people you can trust on your staff or you may have to fulfill the roles yourself. The budgeting for any film is sensitive information, which means there is no reason a **boom pole operator** should know the budget of your film.

The scheduling coincides with your budget as the timeframe in which you film your project factors heavily into your cost. Don't fret though, because there are other producer roles that you can group additional tasks into.

Note: You will need an experienced attorney to develop a non-disclosure agreement (also known as an **NDA**) for your film as this will protect your staff from sharing any information about your project. You can also find sample NDA's online, just make sure you read it and understand it yourself.

Now, **Associate Producers** can also fulfill the line producer functions. Remember, a line producer aids in the arena of budgeting and scheduling. The role of an associate producer is just as vital, and so you could hire an associate producer to fulfill the tasks of the line producer. For any film it's important to clearly define tasks for whomever you hire.

As long as tasks are defined and assigned you may not need as many executive level production staff. Each producer should be held accountable and that is why before anyone comes onboard the roles are clearly defined and they sign your NDA.

Remember, as an independent film producer you want to leverage all of your resources which includes time, money, and people.

A good resource and tool to help with budgeting and scheduling is **UniProducer.com**.

Uni Producer is a motion picture consulting firm that assists in staffing, scheduling, budgeting, and consulting.

Back to **Associate Producers**, think of Associate Producers as **Production Assistants**. Production assistants aid in all facets of the production and the associate producer does as well just at a higher executive level.

Co-Producers can be from one or more countries or businesses that help with development or financing.

As an independent filmmaker this book will certainly show you just how to become an independent producer no matter where you are in the globe.

Planning and Developing

"Two things are infinite: the universe and human stupidity; and I'm not sure about the universe"

Albert Einstein

Unless a major Hollywood film producer is attached to a script or project, producers normally do not invest their very own money in a movie. They usually convince others to back the movie. As an independent filmmaker you may be your only source. Not a major studio, not Uncle Richie or Auntie Millions, YOU! So, planning and developing your film will certainly be a vital step if you intend to get this right the first time.

"The most glorious moments in your life are not the so-called days of success, but rather those days when out of dejection and despair you feel rise in you, a challenge to life, and the promise of future accomplishments.

Gustave Flaubert

Think about **planning and development** as marketing the film. What is your movie idea? You must address, what kind of movie do I wish to make? Who would see my film? Like the old *Temptations* film, which was produced by Otis Williams, he had to pitch the film to himself.

So ask yourself, *"Would I buy this film or a sandwich?"*

You are looking for mind blowing ideas that will attract your audience in.

Once you have that idea, do your research. Find other comparable movies to the idea that you intend to produce. How much has the comparable movie actually grossed?

You can look online at sites like **www.imdb.com** or in trade magazines in your country.

Considering that you are an independent producer you should obtain budgeting software or merely make use of excel.

Organization is key to running a successful film production.

Again, **Uni Producer** is a good source for film scheduling and budgeting. Before you are ready to shoot make certain you have all rights to the film, contracts for cast, crew, and filming locations.

Also, in some nations you might be required to buy an ISAN: International Standard Audiovisual Number.

Similar to an ISBN for books, which is a digital barcode, an ISAN is connected to the audio and visuals.

Visit isan.org for more information.

Also, connect with your **regional movie commissioner** to obtain a little publicity for your film. Notify them of your production and filming days. Some film commissioners will certainly publish a regular listing to the sector reporters on who, what, and also when a film company is in production. This also alerts the local people in case of road blocks and lane closures.

When creating your film, you need to pick the right script. Do you have the budget to make an unusual film comparable to Star Wars or is your spending plan little enough to make a one place love story or scary film?

Think long and hard about these questions and write them down and answer them.

You are also dealing with the legal rights as well as copyrights of the film. You must answer the questions:

Is this an original story?

Did you compose the manuscript or is this script composed by another person?

See to it you get the **movie rights** or **option rights** before you begin filming.

When starting from scratch you would want to outline your story. This is a detailed layout of each scene. An overview goes over what happens, and also when.

Here is an example:
The killer is birthed
The lead women is drinking alcohol at a bench
The killer finds lead woman and falls in love
Etc.

Development is basically the stage where the film remains in its script phase, but you are forming a business plan around it. In this phase, you are working with the script writer,

(if it's not your own script) you are finalizing details for the script, storyline, and also plot. You also want to set up your film as an official business.

As a producer you are in the film business. Make certain to seek advice from your local government or a lawyer for additional information on which entity to file as.

Either an LLC or Corporation should benefit your movie.

Make certain the screenplay that you pick to produce with is well structured before filming. When beginning a script from scratch you will wish to set apart time for revising the script.

Next, hammer out a **treatment**.
A treatment is basically an overview of your film. After your treatment is done write the script in the appropriate writing style.

Any script writing software can help you with that. Then take a fews days off from the script. After you have taken a mini vacation from the script then revise it to fix any kind of plot twist.

A good source for writing screenplays is the "The Screenwriter's Bible, 7th Edition, A Complete Guide to Writing, Formatting, and Selling Your Script" Amazon Affiliate Link (https://amzn.to/2SWOWFz)

Buy this book if you are interested in producing as well as writing your own films.

Storyboard

"We are formed and molded by our thoughts. Those whose minds are shaped by selfless thoughts give joy when they speak or act. Joy follows them like a shadow that never leaves them."

Buddha

After the screenplay is done, completing a **storyboard** is essential for expressing to your crew the flow of the film. A **storyboard** is a comic book like drawing that expresses your film on paper or digitally. A detailed **storyboard** might have the shot list included in it. These illustrations of your film help with the flow and also any adjustments you may want to make.

A **storyboard** aids the director in addition to the cinematographers and various other crew members during production.

Make sure your **storyboard** includes:

A Master Shot - which is an illustration of the whole scene, single, or close shots.

Close Shots are defined as a mapped out close up of the character.

Cutaways are an illustration, such as a close up to disclose a street indication or milk carton.

Your team would certainly benefit from the **storyboard**. The **storyboard** also aids the director in organizing thoughts as well as suggestions that they can communicate with the crew. The shot list should go along with the **storyboard**.

If you can draw, you may consider illustrating the storyboard yourself. Otherwise make the investment to another artist either from www.Upwork.com, or allow Uni Producer to help source the storyboard artist www.uniproducer.com.

You can also use Fiverr www.fiverr.com to find your professional artist.

Once you have actually a completed **script**, a **storyboard** and **shot list**, you will be on your way to a schedule breakdown and a budget for your project.

A great resource for budgeting and also scheduling breakdowns is **www.uniproducer.com**.

As a producer you do not need to recognize exactly how to do every duty specifically, yet you need to recognize what each role provides for your production.

Distribution

**"I have dreamed in my life, dreams that have
stayed with me ever after, and changed my
ideas; they have gone through and through me,
like wine through water, and altered the colour
of my mind.**

Emily Brontë

Do you intend to make a one in a million
breakthrough like *El Mariachi* (producer Robert
Rodriguez), *The Blair Witch Project* (producer
Bob Eick) or *Paranormal Activity* (producer
Jason Blum)? Well, I cannot promise you that
your film will be massively successful, but I can
assure you your movie will be completed.

By the end of this book you will have all the
tools to launch your own movie screening.

You will be the only thing standing in your way.

By recognizing your target market and also where they shop will help you target the right distributor for your film. More questions to ask yourself are: Will individuals that see your film subscribe on Netflix, Hulu, or Amazon or will they most likely go to RedBox or the theaters to see your movie?

Figure out what's the highest performing independent film on those services. At your independent movie screening you can invite anybody you wish to see your film.

If you have an IMDB Pro account you are able to access contact information for agents and distributors. Step out the box, and invite these people to your screening--it could very well change your life.

Now, we will cover this more later but you could utilize the funds from your first screening to host another screening then eventually pay for festival fees or host another screening in another town.

Distributors come in all shapes, kinds, and sizes. Some may handle only foreign movies and others go straight to streaming services, wire network, TV, and so on.

Most filmmakers believe, including myself, that the holy grail of distribution is theatrical circulation with P&A (print & advertising) paid for and upfront money.

Distribution agreements have actually been seen to be around 35% - 50% to the producer and the rest to the distributor.

Some distribution companies want your film to be longer than 70 mins. A feature film is considered to be anything longer than 45 mins.

What will your target market sit through?

What will you endure?

Exceeding Expectations

1. *El Mariachi* had a budget of $7,000. There were no known actors and the film grossed $2 million worldwide.
2. *Paranormal Activity* was working with a $15,000 budget, and grossed $193 million.
3. The movie *Primer* won the Grand Jury Prize at the Sundance Film Festival, and was made for just $7,000. It grossed $840,000 at the box office.
4. *Super Size Me*, is a documentary that was made for $65,000 and grossed $11.5 million.
5. *Napoleon Dynamite* was made with $400,000. It later grossed $40 million.

You may think because these films are not as recent the same potential return on investment is not possible for you. I beg to differ, and now with such high quality inexpensive cameras and social media marketing you could be the next online streaming producer, success story.

Film Representation or Agent

A producer representative can bargain an offer for you. The **representative** or **agent** is the intermediary between the distributors, foreign sales, and your film. Producer **agents** may have 5 or more movies they are reps for because it's how they eat.

They generally obtain 5-15% of the deal they make for you. Do not offer anyone cash ahead of time to represent you unless they are going above and more for you. Remember you have currently made the film or at least have everything you require to make the film.

A **sales representative** or **international sales rep** manages local as well as foreign sales. These agents understand the distributors, exhibitors, and also various other channels to get your film seen.

You can choose as many reps as feasible as long as their exclusive territories do not overlap. They may request to deal with all areas to disperse your film, and it's up to you to approve or deny. You must be aware that some deals may require you pay P&A (Print & Advertising) alone, with the contract. When communicating with the representative let them know what you are looking for.

A couple of points you have to go over with your rep are your deliverables. Your agent will provide you with a sheet of your needed things. These things can consist of DVDs as well as digital documents, trailers, a screener, digital pictures, poster artwork, DCP (digital cinema package), audio, subtitles, commentary tracks, and other documents they may request including Chair of Title Records (to reveal you are the owner of the product).

Some offers may give upfront cash.

Develop a checklist of areas as well as the kind of circulation you are looking for to expose to. Make certain your deals do not go across the very same platform. It can be complicated when picking different representatives in various markets but it depends on you to pick the one that specializes in that market. If you think it's an area where you can successfully disperse your content out like Amazon Prime go for it.

You can have another agent represent your final film in markets that other partners or yourself may be weak in. Inquire about their performance history when assessing your reps and representatives. Have a lawyer examine all your paperwork. Try out **legalzoom.com** service for legal representatives.

In some negotiations you will have the ability to market straight from your individual website unless the contract states otherwise. However, your rights as a producer, permit you to sell merchandise such as t-shirts, hats and more which is another form of marketing.

Finding Distributors

Some significant forms of **distribution** include theatrical, non-theatrical, VOD, TV SVOD, Direct to DVD, direct digital, retail DVD, home video clip, educational circulation, semi theatrical circulation, and also festivals (which I consider festivals a kind of marketing, we will review this in the advertising and marketing chapter). One more circulation form is **Limited Release** which is where a movie theater or supplier books a theater for you and you still may or might not have to pay out of pocket.

Additionally, you can go to different seminars to obtain distribution for your film. Below is a listing of suppliers on my 2020 list.

Movie Distributors

The Numbers -
https://www.the-numbers.com/market/distributors
Independent Filmmakers Showcase -
http://www.ifsfilm.com/Resources/Distributors.php
Video University -
https://www.videouniversity.com/directories/video-a
nd-film-distributors/
Indie Wire -
https://www.indiewire.com/2014/01/indiewires-guide-
to-distributors-at-sundance-2014-31256/#cargo
Uni Producer-
UniProducer.com
Publishers Agents-
publishersagentsfilms.com

UniProducer.com or publishersagentsfilms.com can
help get you access to distribution.

To find a theater near you go to:

Cinematreasures.org

natoonline.org

https://www.indieflix.com/filmmakers.html#_submit-your-film_

http://www.ouatmedia.com/home/

https://www.rljentertainment.com/us-distribution/

AMC Theaters

https://www.amctheatres.com/programs/independen t/submit-your-film

videodirect.amazon.com

https://www.alibris.com/sellers

https://www.booksamillion.com/businessservices/co ntact.html

vhx.tv

Distributors are expecting you to have a screener link that is not shown to the world. You can do this either on vhx.tv (which Vimeo bought), Vimeo, YouTube or any free streaming platform in your country.

For more directories add in your search engine **"Film Distribution Directories"** to find even more movie suppliers.

Before applying or filling out any forms make certain your movie matches the genre they distribute. When contacting the **distributor** let them know your genre. Be aware that most unknown films will go straight to DVD or streaming platforms. Get in touch with the **distributor** by phone, email or personally at an event.

Make them interested in your film. Unless your budget plan is greater than 2 million bucks, do **NOT** tell them your budget. Unless your main actor is an A-List or rising B checklist star, do not mention the actors. What you do state is the: story, factors, press coverage, awards etc. Also mention the type of people that have an interest in your movie and how they reacted to seeing your screening.

If they don't ask, do not tell.

Once they ask for your screener make certain to include a press kit with photos as well as more on your screener site. Consider your film as a business, because **distributors** are. Put yourself in the **distributor's** shoes.

Would this film generate income in their market?

Various other circulation methods are **four walling** or **platforming**.

I recently did a movie tour of one of my films and used the circulation method of four walling/platforming.

Four Walling or **Platforming** allows you to discuss deals with movie theater managers or distributors to premiere your movie on certain days and you can offer your very own tickets and keep the earnings.

You will pay the base fee to rent out the facility on the dates submitted and this can be done in different cities.

If you have had some success with your past screenings you might work out a contract with the theater's booker or supervisor where they can receive money from your film screening instead of you having to pay up front. Make sure if you do go into this agreement, they are not liable to replace your movie for another film even if nobody appears.

Pre-Production

"Never ever tease an old dog; he might have one bite left."

Robert A. Heinlein

Having limited resources, you might choose to write the script on your own. Most Hollywood Producers refrain from writing the screenplay themselves. Don't be stunned at how much time goes into creating your initial film. It has actually been shown time and time again that skimping on the **pre-production** process leads to guaranteed chaos.

Reading this book you're most likely to beat the probabilities. Proper preparation prevents poor performance. Your **Pre-Production** is a road-map to assist you with your entire production.

Filing Paperwork

"Knowledge comes, but wisdom lingers. It may not be difficult to store up in the mind a vast quantity of facts within a comparatively short time, but the ability to form judgements requires the severe discipline of hard work and the tempering heat of experience and maturity.

John Calvin Coolidge

When collaborating with Unions as well as Non-Unions you must understand the policies and regulations to working with unions as well as other organizations. One more good source that can aid with outsourcing, staffing/recruiting, budgeting, scheduling and consulting is **Uni Producer** at **uniproducer.com**

The Movie Script

"The best way to teach your kids about taxes is by eating 30% of their ice cream."

Bill Murray

You'll need a script to start your producing career. This is what producing is about. You have to ask yourself, without the screenplay what are you producing?

There are a lot of books readily available that outline the whole procedure of screenplay writing. But here are some of the principles below.

Working with a Writer to Manuscript Your Concept

"Life is a moderately good play with a badly written third act."

Truman Capote

You can choose to hire someone to write your screenplay either online or someone you know. If your relationship with the **writer** turns adversarial for any reason, you might want to merely call the bargain off, give them their work back then start over. Have a contract that defines the rights as well as duties of the writer. It is often when individuals do not have contracts that things can get a little messy.

Select a writer by watching your preferred films and reviewing the scripts to that film. Seek a **writer** that can write in the style in which you are seeking. These scripts will give you a suggestion of what to anticipate.

Most likely a movie library will have scripts.
Maybe you have the idea but do not recognize
how to put it in words.
Then your project will require a **writer**.

Among one of the most crucial abilities to
search for in a **screenplay writer** is the
capacity to narrate.

Can your **writer** create an engaging tale that
your audience will appreciate?

The **scriptwriter** you choose will have to be
someone who in fact can see your vision might
be better at creating words, personalities, and
scenes.

Optioning a Script

"Growing up is such a barbarous business, full of inconvenience and pimples."

J.M. Barrie

Given that many **scripts** take months and several re-writes to create, it is really practical for a **screenwriter** to anticipate to be paid as necessary. That alone makes getting a manuscript a somewhat much less eye-catching choice for a first-time producer.

There are, of course, methods around this.

When possible, you'll wish to see if you can supply a film writer a percentage of future earnings or backend factors as opposed to money up front as an independent producer.

A producer that wants to obtain a movie's rights will have to purchase the property outright.

A screenplay writer who makes a decision to option the screenplay gives the producer the special alternative or civil liberties to buy the movie script in a specific period of time.

As a novice movie producer, you will certainly be restricted in what you're able to supply someone for their manuscript, screenplay or story.

During this time a producer will look for financing or focus your efforts on working on writing the script yourself.

Crew

"The distinction in between a fair musician as well as an excellent musician is that a good artist can play anything he thinks. The difference in between an excellent musician and also a wonderful artist is what he believes"

Miles Davis

Movie producing is a partnership between you, as the producer, as well as your staff. They are absolutely there to follow your lead. However, likewise, to offer you their time, labor, expertise and suggestions for exactly how to make this a great production they will certainly feel great about seeing their name in credit scores and also the work they have done.

Throughout production the creative force behind a film is the **director**.

A **director's** job is special and also should match the design of the movie in order to be a success. Choose your director, wisely...

The **director** must have a feeling of what the film needs to "feel" like. The **director** needs to also be keen to the design of the film you want to produce.

If you desire to also direct the project make sure you do extensive research on that role. Look up the directors of films that your script is most closely connected with.

In **Pre-Production** there are key people that you will need if you cannot afford the entire crew. I will put plus signs (+) by all the key members that are very necessary to have in place before film production.

Production Crew

Director + - Translates the screenplay into images and sound of a motion picture. Responsible for directing the activities of cast and crew during pre-production, production and post-production. Makes most of the creative decisions during the filmmaking process.

First Assistant Director - Organizes the shooting schedule, helps execute the time efficiently on set, and sorts various paperwork while assisting the director.

Second Assistant Director -Managing logistics of all cast and crew, assist in directing extras, and distribution of production paperwork.

Second Unit Director - Another unit who follows specific directions from the director or producer to capture establishing or other various shots.

Unit Production Manager + - Responsible for preparing the budget and authorizing expenses.

Production Coordinator + - Coordinates the logistics of production. Shipping films, receiving dallies, arranging transportation, and accommodates for actors and crews and any special needs.

Production Assistants - Aiding the producer, director, etc. assisting in whatever manner best aids the production.

Director of Photography + - Responsible for selecting camera, lighting equipment, supervising camera and lighting crews, determining the lighting pattern and exposure for each scene. Their goal is to find ways to use cameras and lighting to tell the story.

Camera Operator + - Responsible for operating the camera at all times and maintaining compositions established by the producer and or director in some cases the director of photography.

First Camera Assistant + - Responsible for appropriate lenses and filters for each shot, setting the lens stop and focus for each shot. Also checking the playback after each scene.

Second Camera Assistant - Loading and unloading film. Setting up the camera. Maintaining paperwork, reports, preparing slates, and cleaning all elements of the camera package.

Costume Designer - purchasing and or designing and supervising costumes for production.

Wardrobe Supervisor + - Maintaining the wardrobe department and dressing actors efficiently during production.

Gaffer + - Is chief electrician and is responsible to the director of photography and makes sure the lighting pattern is safe and efficient.

Gaffer Best Boy - Supervises the operation of the lighting and electrical equipment.

Electricians - Responsible to the gaffer for rigging and operating lighting and electrical equipment.

Generator Operator - Operating and maintaining the electrical generator.

Key Grip - Supervising grip crews, rigging vehicles, building platforms, blacking out windows, and laying dolly tracks.

Dolly Grip - Operating and maintaining crane and dolly.

Location Manager + - Scouting locations, securing permits, negotiating financial, and logistical arrangements for the use of various locations.

Key Makeup Artist - Designs and applies makeup to actors and supervises other makeup artists.

Assistant Makeup Artist - Assistant to the key

makeup artist and responsible for applying

touch ups.

Hair Stylist + - Responsible for the hairstyle

and touch ups.

Body Makeup Person - Responsible for

makeup from the neck down.

Production Designer + - Establishes the look

of the picture, responsible for planning and

supervising the visual design of the overall

production.

Art Director - Responsible for designing and executing sets as conceived by the production designer.

Storyboard Artist + - Creates a multi-panel pictorial representation of the film in advance of production.

Illustrator - Create detailed drawings of scenes, set props, and in accordance to the directors or producer vision.

Set Designer - Designing and executing blueprints and producing models in accordance to the production designer.

Special Visual Effects - Building and operating visual effects.

Set Decorator - Responsible for furnishing the set.

Property Master - Responsible for maintaining props.

Prop Maker - Designing, building and operating any special props.

Publicist + - Responsible to the producer for preparing and arranging promotional information to newspapers, interviews and more.

Still Photographer + - Taking pictures during stages of production for publicity.

Script Supervisor + - Responsible for taking detailed notes during production that aids in post production.

Set Construction Foreman - Key carpenter and supervises set construction for production.

Carpenters - Responsible for the set construction foreman for constructing, delivering, setting up and maintaining construction material for production.

Painters - Painting the set.

Scenic Artist - Works with paint to create a specific look for the film.

Production Sound Mixer + - Responsible for monitoring all quality of production sound. The sound mixer is responsible for slating each take and mixing and balancing audio levels.

Boom Operator + - Responsible for the sound mixer for the placement of the microphone during production. Requires properly positioning of the microphone so that it is not in the way during takes.

Special Effects Coordinator - Responsible for safely executing all special effects during production.

Stunt Coordinator - Responsible for safely planning and executing all stunts for production.

Transportation Captain - The transportation captain is responsible for securing and maintaining production vehicles that are transporting personnel.

Drivers - Drives and chauffeurs key personnel to various sites during location.

Craft Services + - Craft services are a must for any size production because people have to eat and get energy. The craft service person is responsible for providing in between meals, snacks, and beverages for the cast and crew during production.

First Aid Person - If you are doing stunts for your action movie you will need someone who is certified in first aid safety nearby. The first-aid person is responsible for the immediate medical care of any person in the cast or crew requiring medical attention.

A key thing to keep in mind when working with a low budget is...

1: Get all the coverage you need and can.

2: Don't waste time! Particularly if people are volunteering their time.

When you are able to assemble an experienced and extremely proficient crew, this is particularly true. You would be surprised who is willing to help you if you have a good reputation. Considering that you are on an independent spending plan you might lose one or even more staff participants to higher paying contracts, often ideal at the last minute (or even in the midst) of your shoot.

Lots of people are aiming to acquire experience on a film set. An amateur would be delighted to hold a boom pole or keep the shoot free of interference. The key to a successful independent production is getting trustworthy individuals who really care and are willing to work hard and have fun to get the production complete.

Scouting Your Locations

"Patience serves as a protection against wrongs as clothes do against cold. For if you put on more clothes as the cold increases, it will have no power to hurt you. So in a like manner you must grow in patience when you meet with great wrongs, and they will be powerless to vex your mind.

Leonardo Da Vinci

Most local film divisions can assist with searching for locations. Along with having great customer service, your local government film department can also provide photos of the locations and contacts.

As an independent producer other inexpensive or free places to film can be at your family members or crew member's homes or places they can refer you too.

Depending upon the location you are planning on shooting at, you might need to obtain permits from the city or local government. This can be fairly expensive if you are in need of multiple permits.

Table Reads

After you have a final script completed, gather actors and crew somewhere for your table read. The table read allows you to see how the production will sound having actors read aloud the script to the final page.

Make sure you have food at the table read.

Prior to recording you would absolutely want to have a production conference. This is the time to get any type of final words concerning the manuscript or concerns regarding production answered.

"A deal is something you cannot make use of at a cost you can't withstand"

Franklin Jones

Making a movie can be costly if you don't have the right tools of the trade. Some producers can start off a film, but very few can complete a film. Don't think of you before you make the film, think of the financier.

Audio

"Hollywood is wonderful. Anyone who doesn't like it is either crazy or sober."

Raymond Chandler

Have you ever watched an independent film and heard something rattling while an actor or actress were speaking? That was a sound, noise, or audio issue. Noise can be fixed in the post-production phase, but sound is hard to clean up.

There's nothing worse than terrible audio when superimposed on your stunning film. Many people will certainly take bad lights over poor audio any kind of day.

Your **audio** department's task is to catch as much of the actual audio as feasible while eliminating negative sound, such as boom pole, electrical, and also whatever else that the scene does not ask for.

A **sound mixer** is utilized to record sound from several mic sources. A **four-network mixer** is generally sufficient to record a sufficient variety of resources right into a two network (left and right) mix that can either be laid over independently onto the video clip track or fed back right into the cam.

For action scenes, a **lavalier microphone** is the device of choice for catching dialog. The transmitters can be large in some cases, so if doing a long, full-body shot, you may need to make sure to shoot your cast in a way they can hide the transmitter behind their backs, generally under the tee shirt.

A **digital slate** is extremely useful and used to give a number for the audio time code in addition to the scene, as well as reel numbers.

Camera

"The distinction in between sex and also love is that sex alleviates tension and love causes it."

Woody Allen

Given a minimal budget, you'll need to make some hard decisions regarding where you'll be spending your cash. If you take a long look at what is essential as well as your particular circumstances, you might have to re-evaluate what you thought was necessary.

The look of your film will identify the tone, and that begins at the lens. It is best to obtain a few great lenses. As an independent film producer you should always be mindful of the quality of the item.

A standard **camera** now is 4k.

Cameras like **Blackmagic**, **Red**, and others can fulfill that.

Craft Services

"In this business, until you're known as a monster, you're not a star."

Bette Davis

You're responsible for keeping your people fed and also happy throughout the shoot. This generally consists of at least one catered dish as well as an unexpected amount of coffee.

Since many low-budget shoots will feed their crew on a tight budget, you can truly stimulate a lot of goodwill towards your production by giving top quality food.

Be sure you give lots of alternatives for your staff members, consisting of vegetarian or kosher choices. The majority of catering experts are well aware of this as well as give a lot of alternatives for every person.

Make sure you have **catering** or **craft solutions**. This aids your cast and staff and also helps everyone remain energized. You need to look after your individuals. If it's just coffee, chips, and doughnuts your team will appreciate it.

Now, if there are no **craft services** count on me, the team will certainly get upset and the work would not be done right. In addition, make sure you have a bathroom nearby.

No one likes to use the toilet in front of everybody. Hold high standards even on a low budget. When the job is completed the crew along with actors will certainly discuss your project with other individuals.

Just how do you want them to spread the word about your production?

Lighting

"Just as treasures are uncovered from the earth, so virtue appears from good deeds, and wisdom appears from a pure and peaceful mind. To walk safely through the maze of human life, one needs the light of wisdom and the guidance of virtue.

Buddha

Make sure you have at least three **lights** and back up **lights**. Your DP (Director of Photography) should advise you on which set they have or which ones to get. Having good **lights** can save you an ample amount of production time.

Insurance

"The man who makes everything that leads to happiness depends upon himself, and not upon other men, has adopted the very best plan for living happily. This is the man of moderation, the man of manly character and of wisdom.

Plato

One topic many books don't talk about is **insurance**. **Insurance** coverage implies you'll be in a much better position to use a broader series of locations, and protected in case someone gets injured. It's not a major requirement for a small shoot. If you're funding the entire job out of your very own pocket, you may want to have insurance just in case.

You can spend ample time in development and pre-production to make a great script and get all your paperwork in order, but if the cast and crew are not working together in a professional manner the movie will not get done.

Scheduling

As the saying goes, "Time is money". It is extra real during the production of your initial movie. Given that you likely will be on a strict budget, planning your entire day from the initial casting contact to the last cover is critically important.

The production meetings you've had with your major crew participants, allows you to get out information. For smooth operations, you must stick as closely to this road-map as you potentially can. See to it that you are organizing your documentation well. You never know when issues may arise.

Call sheets are created for every day of production. They are published or emailed to cast as well as crew a day before the job day starts. They include crucial details like the location for filming.

You must have an early adequate call time to enable everyone to get settled in as well as ready before delving into your aggressive production timetable. Films run on a very tight routine, your film is no different.

A crew member can stand up a production, which ends up triggering everybody else to stand around waiting for something to happen.

Whether you're producing for the very first time,or not you should trust your staff to do their work, so you can do your own. That doesn't indicate disregarding what others are doing, as you will still need to keep an eye out for instances and also errors where mistakes are likely to happen.

Equally as important as beginning promptly is leaving promptly. Especially if they are due on set first thing the following early morning.

Assuming that you've put the leg work in on your pre-production, this will certainly be much less of a concern, however troubles have a tendency to come up at the last moment that will certainly require you to make some hard choices as to scenes that you might need to drop or even adjustments to the script.

Preparing to make such choices is where your ability as a leader will certainly be required.

Make Up, Hair, and Wardrobe

**"If you don't like how things are, change it!
You are not a tree."**

Jim Rohn

Getting your cast in **makeup** and **wardrobe** a few days ahead of time will certainly be vital for helping you promptly convey what you need when you get on set.

WRAPPING

"If I am walking with two other men, each of them will serve as my teacher. I will pick out the good points of the one and imitate them, and the bad points of the other and correct them in myself.

Confucius

Film is a collective initiative, and your crew should recognize they can provide you with advice at any time. As a new and independent producer, you should make sure that you listen to all their concepts, take them into consideration as well as be confident to make a decision.

In very little productions, the producer can additionally handle DP (Director of Photography) and director responsibilities, though things normally run more smoothly the more tasks you can hand off.

This is your vision, and it's your job to see to it that what you think of is really what's being filmed.

You will function as the final word, and also considering that there's a lot taking place, it's tough to rise above all the complication as well as emphasis upon nothing past what's needed.

If you have actually had production stills taken, be sure to obtain copies of those as soon as possible. The internet makes it easy to share such information, offering your crew something to show others while they're waiting on you to put the final product together, and you want to wait until your film is completed to release it.

Once you have all your footage and it matches with the script then, it's a wrap.

Post-Production

"How far you go in life depends on your
being tender with the young,
compassionate with the aged, sympathetic
with the striving, and tolerant of the weak
and strong. Because someday in life you
will have been all these."

George Washington

In **post-production** is where you'll be bringing
your vision to life. You'll be utilizing this
process to take those diverse shots and
assemble them right into a systematic whole.

This is additionally the process by which you'll
put together production stills and choose the
best shot from a large number of takes. This
process can often take much longer than the
actual shoot.

During **post-production** your movie may be
edited out of order from the screenplay so
being really organized aids with an effective
post-production flow.

A very first draft of a film is normally a lot longer than the final film. If you broadly tell your editor I don't like it due to the fact that it's dark they will attempt to brighten up the movie, but it could destroy the entire film. Especially if you were to only reference the timestamp at 20:03.

The **picture editor's** edits tell the actual tale from the clips. They value the timing of the movie and will make each cut matter. An **assistant editor** could be helpful to finish the job quicker. The **assistant editor** assists with arranging footage, sound data, making transfers, and sync problems. Employing an experienced non-technical editor can likewise reduce your process down and cost you money.

When in **post-production** be sure to back up your video footage. You will need **terabyte hard drives**. You will need double the size your editor asks for. Depending on your resolution you would certainly need at least an **8TB (eight terabyte)** to hold your video footage and also 8 more as back-up. I suggest the **Seagate** or **Raid** drives.

Usually, the process entails creating a rough cut that you'll use as your guide to put together a last cut. You'll be taking notes from the raw video for your editor if you want. You can save them time by spending some time before you enter and also trashing the cuts that are clearly not ideal.

This is very often done when you attempt to develop in-camera impacts that need numerous takes. You'll intend to trash the clearly unsuitable takes so you can use your edit time as effectively as possible.

First and foremost, as a naturally visual tool, you'll be aiming to create a great looking movie. Your **editor** will be splicing and dicing together a story throughout this procedure. **Special effects** are typically included typically after the rough cut.

It is not uncommon to do the harsh edit on your home computer. It's up to you as well as very reliant upon your budget, since **editors** typically bill by the hour.

CREDITS

"You see, in life, lots of people know what to do, but few people actually do what they know. Knowing is not enough! You must take action."

Tony Robbins

Credits should be included in the beginning and end of your movie. In some cases a title may be in the middle of the film to display a new character or location. Some stars sometimes negotiate in their contracts where they want **credits** added.

Final Edits

As it relates to **color correction** regardless of how excellent your lighting is, you'll be doing some shade improvement to offset variables to blend your film together.

It doesn't matter how great your cast or sound techs are, you'll probably have to do a bit of sound **audio** work. This will be carried out in a recording studio, normally with your cast.

Doing as little of this as possible is definitely the goal, yet it's hard to avoid. If it simply isn't right, don't be afraid to change the sound. If the **audio** and **pictures** don't appear to match, you'll know and if you know everyone else will too.

Even major motion pictures will require some work done to the sound. This work consists of adding songs, audio effects and also in some cases re-recording dialog. You can also make use of various voices to lip-sync and even run dialog via an electronic filter to transform the pitch or timbre.

Again, while much of this can be performed in a home tape-recording studio, it's always valuable to seek the help of an expert that has actually done this for some time and wants to trade or donate services for the opportunity at a credit scores (This is not in reference to an actual credit score, this is referring to the sound scorer being given credit if they choose to donate their time) as well as a possible job working on your next production that really pays.

Audio simply consists of creating the sound of a space. Another typical use of an audio session is for **ADR**. **ADR** is where the cast come in to retake their audio where they have screwed up their lines in previous takes.

Other things to consider are foley or **sound effects** in your film such as hits and punches, music, and special effects. **Voice overs** are also done in the ADR stage, especially in the case of trailers. Voice overs consist of someone's voice narrating a portion of a film.

A good example is Morgan Freeman and nature documentaries produced on the Discovery Channel.

Once your film is done, watch it **3** times. Upload it to a screener site, burn it to 4 DVD's and begin to work on the trailer.

As soon as you're ultimately pleased with what you've got, the first thing you wish to do is to show what you have. Show someone who you know. If they don't get it, you may need to go back and also re-cut it. If they enjoy it, it's time to make copies.

Marketing

**"Most great people have achieved their greatest
success just one step beyond their greatest
failure."**

Napoleon Hill

What stands apart in your movie?

What is your film about?

What sort of genre is your movie?

Why did you watch the last film you watched?

*Is it because it was on your favorite streaming
platform, or is it because a buddy told you
about it?*

This is marketing.

Your marketing strategy should indicate how
you are going to advertise your movie.

*Just how are you going to get people to see
the movie?*

The first thing to present to the world is a poster then a trailer.

Study film posters to learn just how you intend to portray your movie. Ensure you include your lead stars names, title of the movie, tag line and also production company and filmmakers name. Use this poster in your email, social media sites, stickers, tees, mugs, press sets on your site and also all over a photo.

Get with an expert graphic developer to produce this poster. Make certain they are proficient at photoshop or a few other editing software applications to depict your poster.

Take images of your cast and also crew in a studio setup for the poster cover. Employ a professional photographer to record the main photo you would intend to make use of.

Send out the photo to the graphic designer and let them work. Collaborate with them to share your vision.

Have a countdown for your poster on other websites as well as social media.

You can obtain concepts for your poster at **movieposters.com** as well as **postwire.com**.

You may think of film festivals as a form of distribution yet it's not. If your film is revealed at a festival this is **advertising**.

What are the most motivating minutes to you in your movie?

It is an art to make a film trailer.

Once you have made the trailer, reveal a couple of individuals and obtain comments from it.

You need to get individuals speaking about your movie, interact with other writers, reporters, blog owners, Youtuber's and movie spectators, to get a buzz about your film.

Develop a connection with event supervisors, add them to your network on Twitter, LinkedIn or any other social networks electrical outlet.

Marketing on your website should include the following:

1. Email Opt In
2. PDF to press release
3. Trailer
4. Behind the Scene Clips
5. Endorsements
6. Pictures
7. Buy or Pre Order Button
8. Information on Upcoming Screenings
9. Reviews
10. New insurance coverage if any,
11. Social Networks Sharing Switches
12. ...and also anything else you think your audience wishes to see.

Press Releases

For your press releases you would want them sent to as many people as possible. You can make use of these sites for your press.

www.prnewswire.com

sendtopress.com

https://express-press-release.net/

preleap.com

prolog.org - totally free press release service.

ereleases.com

businesswire.com

epressreleases.org

newswire.com

gebbieinc.com

Merchandise

If you are going to be selling merchandise, check out these sites.

www.moneybooker.com

clickbank.com

paypal.com

1shoppingcart.com

e-junkie.com

Distribution

Distribution is a major subject and is also a business in its very own right, yet some new alternatives have actually opened over the last few years for those aiming to make money.

Take my advice, **market via podcast.**

podcastally.com

podcastdirectory.com

Talkers.com

Steps to Distribution

1. **Film Screening:** Setting up a film screening can be simple once your film is complete. Hosting your own screening is key because the balls in your court. You are not waiting for an interested buyer or agent, they will come to you, if you are lucky.

By hosting your own screening you are not waiting on the festival to start or worry about if your film is selected or not, your film is the main attraction. Hosting your own screening of your film can include intro trailers to your up and coming content or others that have paid for your programming.

Invite your local press, bloggers, and friends that have a following on social media. Invite the new contacts that you have made since the start of your production. You can also sell merchandise at your screening to recoup any expenses that you may have paid the exhibitor.

2. **Finish your movie and watch it 3 times.** I recommend 3 times because you first would want to watch the picture. Watch it in silence. Secondly, you would want to watch for sound, without pictures. Third, you would want to watch with sound and picture, taking notes during each phase.

3. **Contact a local theater or any place that hosts events.** I once screened a documentary in a bar in Atlanta. Negotiate with the owner or manager and tell them what your film is about if they are interested. Some people only want the deposit and will leave you to your film. Other art theaters like The Plaza in Atlanta will support you and your budget.

These places may range in price depending on the time and day, location, and length of your screening. These places can range from $500 to a few thousand dollars per screening time. Once you have negotiated the right deal for your screening, test out the screen with your film so there are no hiccups during your actual film date.

If you want to qualify for the Oscars they require you to screen a film for a week, three times per day in either Los Angeles or New York.

See the rules here:

https://www.oscars.org/oscars/rules-eligibility

4. **Market your event:** Once you have your set location and are pleased with your deal then begin to market your event. If you have distributors or agents arriving make sure you prepare a press kit and free DVD's.

You can sell your DVDs to family, friends, and supporters. Talk with local churches or clubs that may be interested in sharing your event with their members. Remember your target audience, if it's not that type of film for that particular organization don't bother sending it to them. Pay for affordable advertising in newspapers or social media. Start at least a month in advance. Most major motion pictures start promoting 6 months in advance.

5. **Host your event.** Make sure you have a red carpet and a step and repeat so guests can take pictures. Make sure you have your merchandise so you market and recoup your money. Make sure you have a microphone so that people can hear you speak. Talk with distributors and agents afterwards. They will approach you if they are interested in taking on your film. If they don't approach you send them a follow up email.

Film Terms and Definitions

Automated Dialog Replacement (ADR): This is when the cast comes in to retake their audio where they have screwed up their lines in previous takes.

Agent: A person who acts on behalf of your film product or represents you. Your agent may also represent others so it is important to verify there is no conflict of interest.

Art Director: This person is responsible for designing and executing sets as conceived by the production designer.

Assistant Editor: This person assists with arranging footage, sound data, making transfers, and sync problems.

Assistant Makeup Artist: This person is an assistant to the **Key Makeup Artist** and responsible for applying touch ups.

Assistant Producer: This person works with the producers throughout the production process, thinking of them as a producer's right hand.

Associate Producer: This person works as an administrator with the production staff.

Audio: The sound or noise connected to a film.

Blackmagic: A camera used for film projects and can be found in 4k and 6k.

Body Makeup Person: The person responsible for makeup from the neck down.

Boom Operator: The person responsible to the sound mixer for the placement of the microphone during production. Requires properly positioning of the microphone so that it is not in the way during takes.

Call sheets: These are schedules of production published or emailed to cast as well as crew a day before the job day starts. They include crucial details like the location for filming.

Camera: A device for recording visual images in the form of photographs, film, or video signals.

Camera Operator: Responsible for operating the camera at all times and maintaining compositions established by Producer and or director in some cases director of photography.

Carpenter: This person is responsible to the set construction foreman for constructing, delivering, setting up and maintaining construction material for production.

Close Shots: A mapped out close up of the character.

Co-Producer: This can be from one more country or business that helps with development or financing.

Color Correction: Regardless of how excellent your lighting is, you'll be doing some shade improvement to offset variables to blend your film together.

Costume Designer: Purchasing and or designing and supervising costumes for production.

Craft Services: A must for any size production because people have to eat and get energy. The craft service person is responsible for providing in between meals, snacks, and beverages for the cast and crew during production.

Credits: Closing credits or end credits are a list of the cast and crew of a particular motion picture, television program, or video game. Where opening credits appear at the beginning of a work, closing credits appear close to, or at the very end of a work.

Cutaways: An illustration such as a close up to disclose a street indication or milk carton.

Digital Slate: This is extremely useful and used to give a number for the audio time code in addition to the scene, take as well as reel numbers.

Director: This person is special and also should match the design of the movie in order to be a success. The director must have a feeling of what the film needs to "feel" like. The director needs to also be keen to the design of the film you want to produce.

Director of Photography: This person is responsible for selecting camera, lighting equipment, supervising camera and lighting crews, determining the lighting pattern and exposure for each scene. Their goal is to find ways to use cameras and lighting to tell the story.

Distributors: This person comes in all shapes, kinds, and sizes. Some may handle only foreign movies and also others streaming service, wire network, TV and so on.

Dolly Grip: Operating and maintaining crane and dolly.

Drivers: This person drives and chauffeurs key personnel to various sites during location.

Eight Terabyte: A hard drive file size that can hold storage.

Electricians: They are responsible to the gaffer for rigging and operating lighting and electrical equipment.

Executive Producer: They are attributed to the film by creating the economic and/or creative package that make the motion picture possible. They can supply money for insurance policies, gap money, bridge cash, and also even start-up cash.

First Aid Person: If you are doing stunts for your action movie you will need someone who is certified in first aid safety nearby. The first-aid person is responsible for the immediate medical care of any person in the cast or crew requiring medical attention.

First Assistant Director: This person organizes the shooting schedule, helps execute the time efficiently on set, and sorts various paperwork while assisting the director.

First Camera Assistant: This person is responsible for appropriate lenses and filters for each shot, setting the lens stop and focus for each shot. Also checking the playback after each scene.

Foley: These are sound effects in your film such as hits and punches, music, and special effects.

Four Network Mixer: This is a channel controller that is generally sufficient to record a sufficient variety of resources right into a two network (left and right) mix that can either be laid over independently onto the video clip track or fed back right into the cam

Four Walling: Also known as platforming allows you to discuss deals with movie theater managers or distributors to premiere your movie on certain days and you can offer your very own tickets and keep the earnings. You will pay the base fee to rent out the facility on the dates submitted and this can be done in different cities.

Gaffer: This is the chief electrician and is responsible to the director of photography and makes sure the lighting pattern is safe and efficient.

Gaffer Best Boy: Supervises the operation of the lighting and electrical equipment.

Generator Operator: Operating and maintaining the electrical generator.

Hair Stylist: This professional is responsible for the hairstyle and touch ups.

Illustrator: Create detailed drawings of scenes, set props, and in accordance to the directors or producer vision.

International Sales Rep: This representative manages foreign movie sales.

Key Grip: This person supervises grip crews, rigging vehicles, building platforms, blacking out windows, and laying dolly tracks.

Key Makeup Artist: This professional designs and applies makeup to actors and supervises other makeup artists.

Lavalier Microphone: This is the device of choice for catching dialog. The transmitters can be large in some cases, so if doing a long, full-body shot, you may need to make sure to shoot your cast in a way they can hide the transmitter behind their backs, generally under the tee shirt.

Limited Release: This is where a movie theater or supplier books a theater for you and you still may or might not have to pay out of pocket.

Line Producer: This person is in charge of remaining within the budget plan.

Location Manager: This person handles scouting locations, securing permits, negotiating financial and logistical arrangements for the use of various locations.

Master Shot: This is an illustration or filming of the whole scene in a single shot.

Movie Producing: A partnership between you, as the producer, as well as your staff to get a motion picture complete.

Movie Rights: These are rights under copyright law to produce a film as a derivative work of a given item of intellectual property.

Option Rights: An option is a contractual agreement between a potential film producer (such as a movie studio, a production company, or an individual) and the author of source material, such as a book, play, or screenplay, for an exclusive, but temporary, right to purchase the screenplay, given the film producer lives up to the terms of the contract.

Painters: Painting the set.

Picture Editor: This person tells the actual tale from the clips.

Planning and Development: The idea for a film is the initial process for a producer.

Platforming: Also known as four-walling allows you to discuss deals with movie theater managers or distributors to premiere your movie on certain days and you can offer your very own tickets and keep the earnings. You will pay the base fee to rent out the facility on the dates submitted and this can be done in different cities.

Post-Production: Post-production is part of the process of filmmaking, video production, video production and photography. Post-production includes all stages of production occurring after shooting or recording individual program segments. (source: Wikipedia)

Pre-Production: The process of planning some of the elements involved in a film, play, or other performance. There are three parts in a production: pre-production, production, and post-production. Pre-production ends when the planning ends and the content starts being produced.

Producer: This person is associated with all aspects of the filmmaking procedure, consisting of choosing the film writers, the casting process, editing procedure and working with more roles.

Production Assistants: This person aids the producer, director, etc. assisting in whatever manner best aids the production.

Production Coordinator: This person coordinates the logistics of production. Shipping films, receiving dallies, arranging transportation, and accommodates for actors and crews and any special needs.

Production Designer: Establishes the look of the picture, responsible for planning and supervising the visual design of the overall production.

Production Sound Mixer: This person is responsible for monitoring all quality of production sound. The sound mixer is responsible for slating each take and mixing and balancing audio levels.

Prop Maker: Designing, building and operating any special props.

Property Master: This person is responsible for maintaining props.

Publicist: This person is responsible to the producer for preparing and arranging promotional information to newspapers, interviews, and more.

Raid: A brand similar to Seagate that sells hard drives in file size 4TB or 8TB

Red: A brand of motion picture cameras that are often used for major motion pictures.

Regional Movie Commissioner: This is specialized personnel that manages film for a government entity.

Representative: A person who acts on behalf of your film product or represents you. Your representative may also work with other clients so it is important to verify there is no conflict of interest.

Sales Representative: This person represents a movie to aid in distribution and marketing.

Scenic Artist: This person works with paint to create a specific look for the film.

Screenplay Writer: The writer of a script.

Script: The written text of a play, movie, or broadcast. (source: Wikipedia)

Script Supervisor: Responsible for taking detailed notes during production that aids in post-production.

Scriptwriter: The person who develops a storyline for a play, movie, or broadcast.

Seagate: A brand similar to Raid that sells hard drives in file size 4TB or 8TB

Second Assistant Director: Managing logistics of all cast and crew, assisting in directing extras, and distribution of production paperwork.

Second Camera Assistant: Loading and unloading film. Setting up the camera. Maintaining paperwork, reports, preparing slates and cleaning all elements of the camera package.

Second Unit Director: Another unit who

follows specific directions from the director or

Producer to capture establishing or other

various shots.

Set Construction Foreman: Key carpenter

and supervises set construction for production.

Set Decorator: Responsible for furnishing the

set.

Set Designer: Designing and executing

blueprints and producing models in accordance

to the production designer.

Shot List: In filmmaking and video production, a shot is a series of frames that runs for an uninterrupted period of time. Film shots are an essential aspect of a movie where angles, transitions and cuts are used to further express emotion, ideas and movement.

Sound Effects: Sound effects are also known as foley in your film such as hits and punches, music, and special effects.

Sound Mixer: Responsible for monitoring all quality of production sound. The sound mixer is responsible for slating each take and mixing and balancing audio levels.

Special Effects: An illusion created for movies and television by props, camerawork, computer graphics, etc. (Wikipedia)

Special Effects Coordinator: Responsible for safely executing all special effects during production.

Special Visual Effects: Building and operating visual effects.

Still Photographer: Taking pictures during stages of production for publicity.

Storyboard: A comic book like drawings that expresses your film on paper or digitally. A detailed storyboard might have the shot list included in it.

Stunt Coordinator: Are responsible for safely planning and executing all stunts for production.

Terabyte Hard Drives: This is the size of a hard drive that can hold your footage. You will need double the size your editor asks for. Depending on your resolution you would certainly need at least an 8TB (eight terabyte) to hold your video footage and also 8 more as back-up. I suggest the Seagate or Raid drives.

Transportation Captain: The transportation captain is responsible for securing and maintaining production vehicles that are transporting personnel.

Treatment: A treatment is basically an overview of your film. After your treatment is done write the script in the appropriate writing style.

Uni Producer: A motion picture consulting firm that specializes in recruiting, crowdfunding, scheduling, and budgeting.

Unit Production Manager: Responsible for preparing the budget and authorizing expenses.

Voice Overs: Voice overs consist of someone's voice narrating a portion of a film.

Wardrobe: Clothing used for the production.

Wardrobe Supervisor: Maintaining the wardrobe department and dressing actors efficiently during production.

Writer: The artist that develops a script.

Resources and Contacts

Crowdfunding for Your Movie

1. UniProducer.com

2. Kickstarter.com

3. Indiegogo.com

Additional Film Resources

1. https://filmmakers.com/

2. podcastally.com

3. podcastdirectory.com

4. Talkers.com

5. moneybooker.com

6. clickbank.com

7. paypal.com

8. 1shoppingcart.com

9. E-junkie.com

10. prnewswire.com

11. sendtopress.com

12. https://express-press-release.net/

13. preleap.com

14. prolog.org

15. ereleases.com

16. businesswire.com

17. epressreleases.org

18. newswire.com

19. gebbieinc.com

My hope is that you follow this guide and that I see your next project on the big screen.

"You take on the responsibility of making your dreams a reality."

Les Brown